TANDEM Activity BOOK

a creativity vehicle built for two

By Lea Redmond

Illustrated by Bureau of Betterment

Hello You!
Hello You, Too!

Just like a tandem bicycle, this book is built for two. You both will get to share the small adventures between the covers by bringing your pens and ideas to the pages simultaneously. The playful activities inside guide you to write, draw, and share, all with an open book between you. You will walk down memory lane, play simple games, and daydream together.

You can do the activities in any order, so each time you sit down to work in the book, flip to whatever page most intrigues you both. Some of the activities, like the memory games and thumb wrestling, can be enjoyed again and again.

Have fun!

CHRONICLE BOOKS
SAN FRANCISCO

Here's why we get along so well . . .

Here's why we get along so well . . .

Draw something ordinary that you think deserves to be put on a pedestal. Rotate the book and explain your choice.

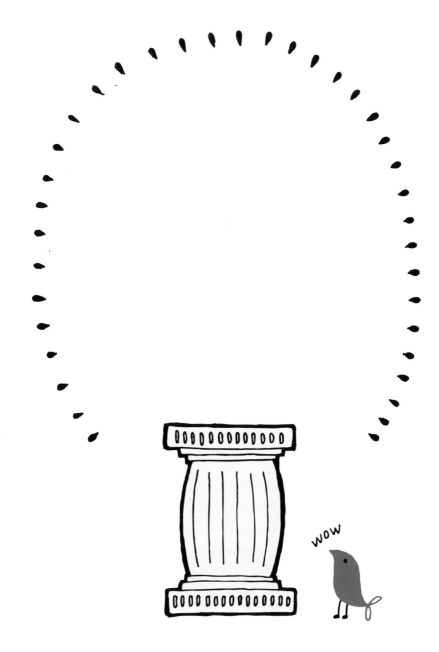

wow

Draw something ordinary that you think deserves to be put on a pedestal.
Rotate the book and explain your choice.

finish

start

finish

start

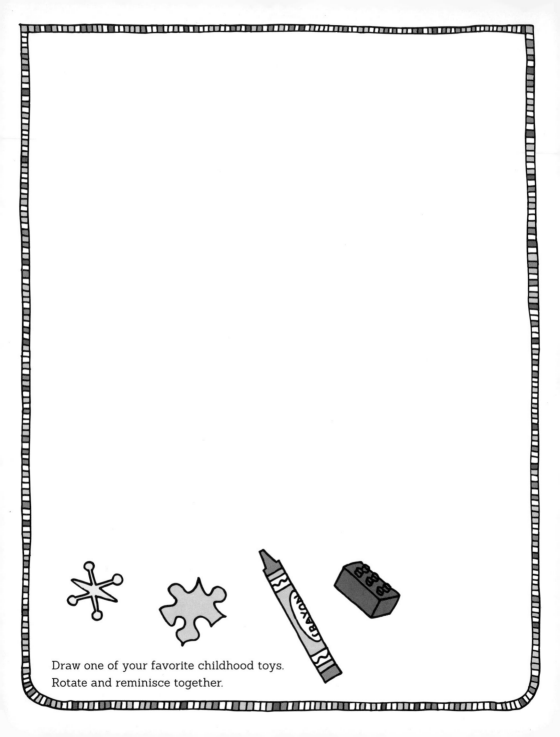

Draw one of your favorite childhood toys.
Rotate and reminisce together.

Draw one of your favorite childhood toys.
Rotate and reminisce together.

If you could attend any event or show at any time in history, what would it be?

PRESENTING

AT

DATE

TIME

NOTES

TICKET NO.
714

ENJOY THE SHOW

If you could attend any event or show at any time in history, what would it be?

PRESENTING

AT

DATE

TIME

NOTES

TICKET NO. 435

ENJOY THE SHOW

Illustrate and write a postcard to your friend.
"Send" it by rotating the book!

Illustrate and write a postcard to your friend.
"Send" it by rotating the book!

Have a tiny writing contest. Who can write smaller?

Have a tiny writing contest. Who can write smaller?

Do you remember your dreams? Share one.
(Write or draw.)

Draw a map showing how to get from your home to a favorite restaurant, park, or other place that you love. Try to make the map from memory. Then rotate, and see if you can guess your friend's favorite place just by looking at the map.

Color in a friendship bracelet for your friend.
Inquire about his or her favorite colors before you begin.

Color in a friendship bracelet for your boy/best friend.
Inquire about his or her favorite colors before you begin.

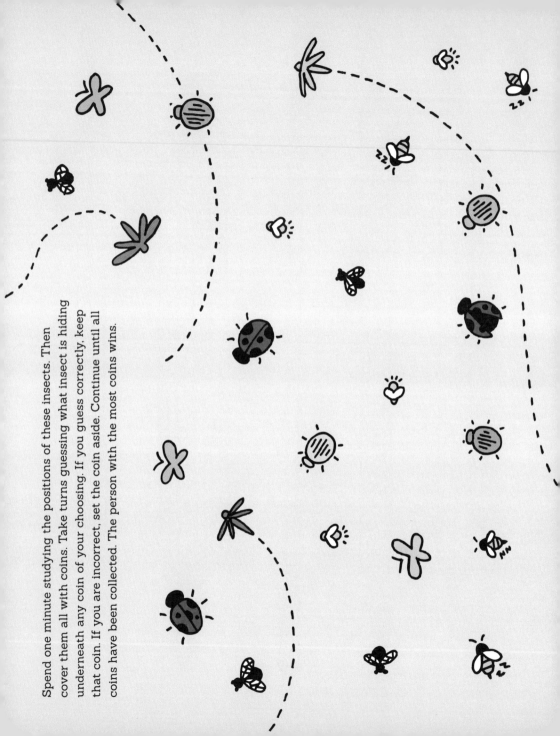

Spend one minute studying the positions of these insects. Then cover them all with coins. Take turns guessing what insect is hiding underneath any coin of your choosing. If you guess correctly, keep that coin. If you are incorrect, set the coin aside. Continue until all coins have been collected. The person with the most coins wins.

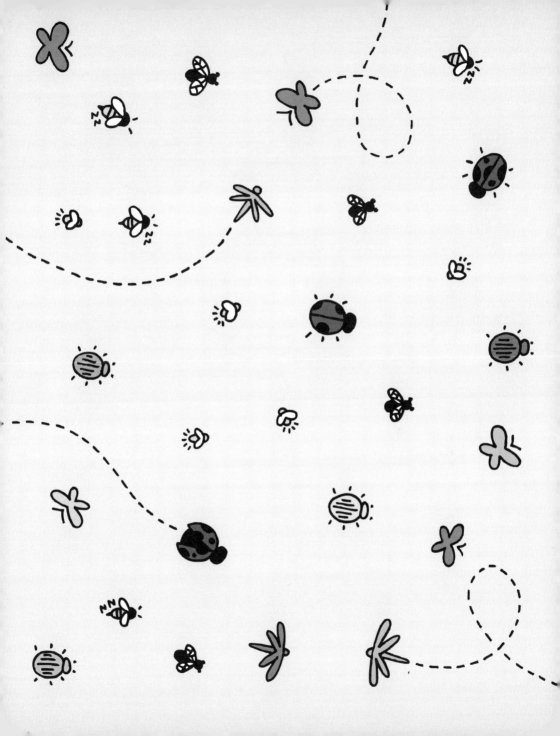

Instant message each other with words or drawings.
Alternate turns as you fill in the speech bubbles.

Draw the sort of outfit you would have worn a long time ago. Would you still want to wear it? Rotate and share. Did your friend draw something you would ever want to wear?

Draw the sort of outfit you would have worn a long time ago.
Would you still want to wear it? Rotate and share. Did your friend
draw something you would ever want to wear?

Design some money.
Who or what would you commemorate on these coins and bills?

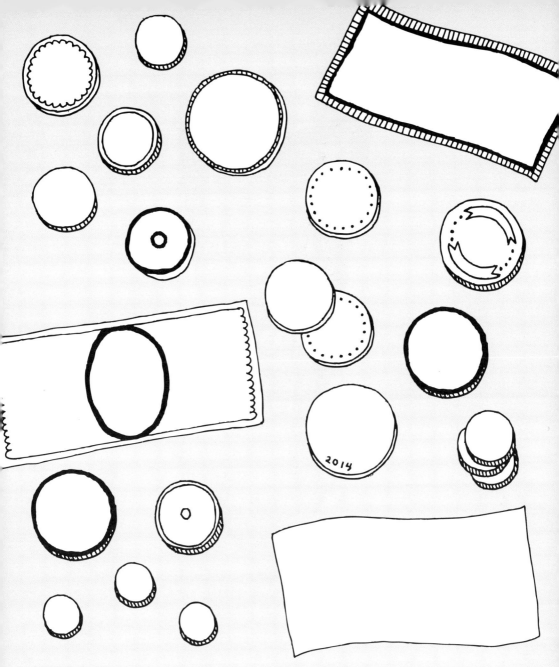

Design some money.
Who or what would you commemorate on these coins and bills?

With the other half of the book folded under this half, take turns spinning the book on a table. Look in the direction of the arrow and find something—anything—to talk about. Try to make it interesting. Draw it on the next page.

Together, fill this time capsule to be opened hundreds of years from now. Only add items that you both agree belong in it.

SECRET!

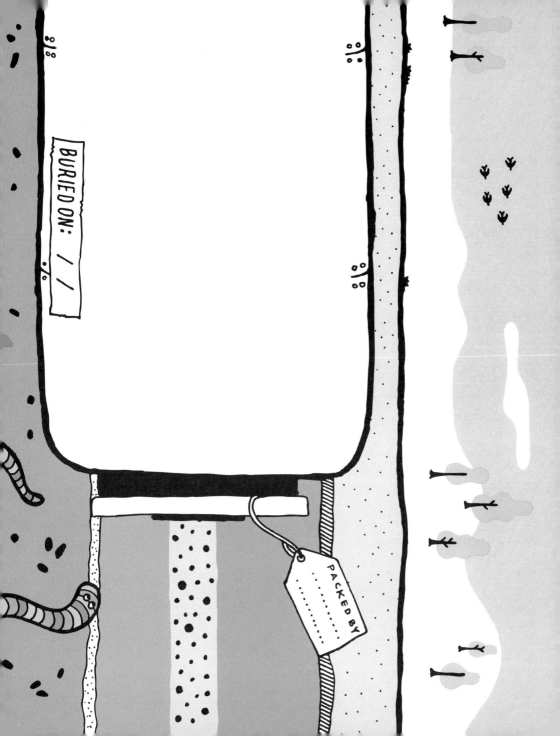

Go on a walk outside together. Find a beautiful flower or leaf and press it here between these two pages.

North Pole

bring gloves

the equator

45°

45°

✳ OBJECTS MAY APPEAR WIDER ON PAPER

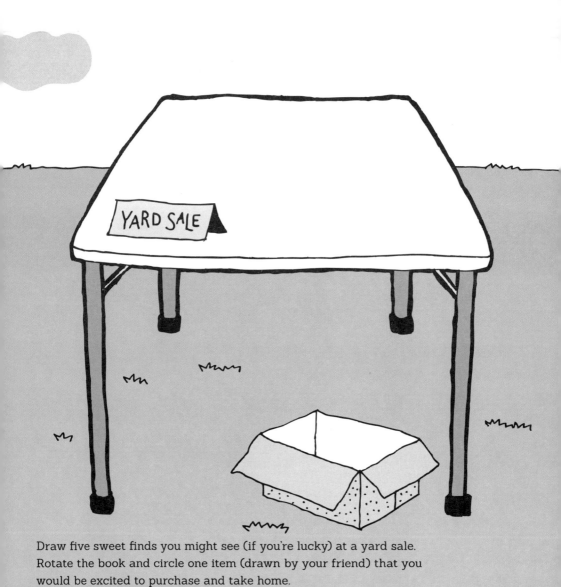

Draw five sweet finds you might see (if you're lucky) at a yard sale. Rotate the book and circle one item (drawn by your friend) that you would be excited to purchase and take home.

Draw five sweet finds you might see (if you're lucky) at a yard sale.
Rotate the book and circle one item (drawn by your friend) that you
would be excited to purchase and take home.

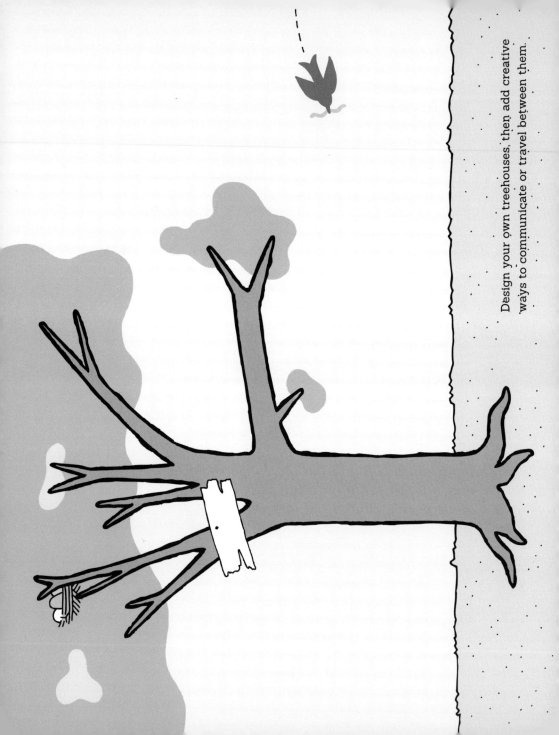

Design your own treehouses, then add creative ways to communicate or travel between them.

Pull an object out of your purse, pack, or wallet. Set it
on this page. Tell its true story or make one up.

Pull an object out of your purse, pack, or wallet. Set it
on this page. Tell its true story or make one up.

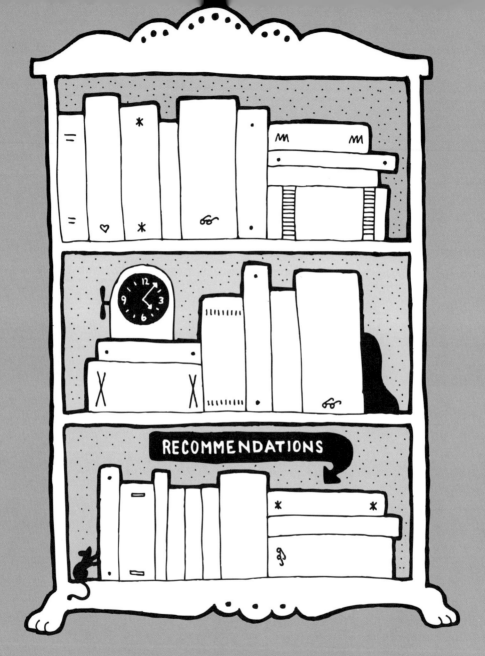

RECOMMENDATIONS

Fill in the titles of your favorite books. On the bottom shelf, put reading recommendations for your friend. Rotate the book and explain some of your choices. If you can quote any lines by heart, do so.

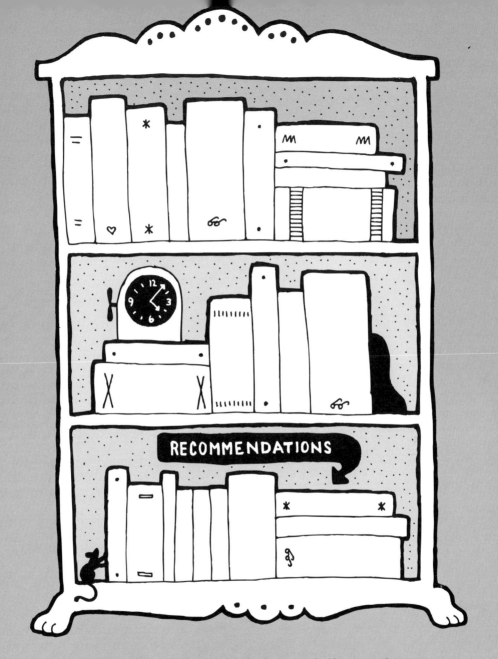

Fill in the titles of your favorite books. On the bottom shelf, put reading recommendations for your friend. Rotate the book and explain some of your choices. If you can quote any lines by heart, do so.

Pick up the book and stand it up like a tent. Draw each other's portraits simultaneously without looking down at the paper along the way. Rotate and enjoy!

Pick up the book and stand it up like a tent. Draw each other's portraits simultaneously without looking down at the paper along the way. Rotate and enjoy!

Leave something wonderfully
silly or perfectly thoughtful in
your friend's mailbox.

Leave something wonderfully silly or perfectly thoughtful in your friend's mailbox.

Tell your friend some jokes. Write them here.

Tell your friend some jokes. Write them here.

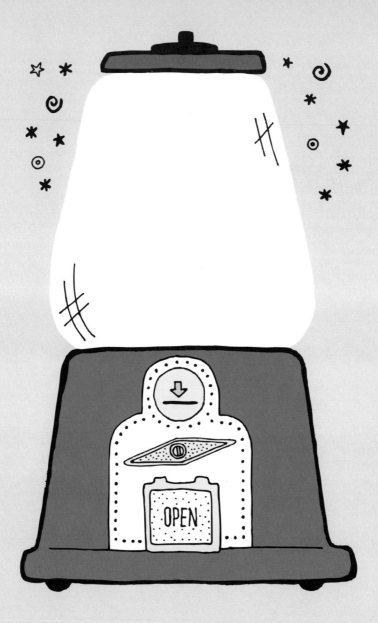

STEP 1: Fill this vending machine with something wonderful. Then rotate the book.

STEP 2: If you'd want to buy one of these wonderful things while walking past, do a rubbing of a coin on this page using pencil or crayon.

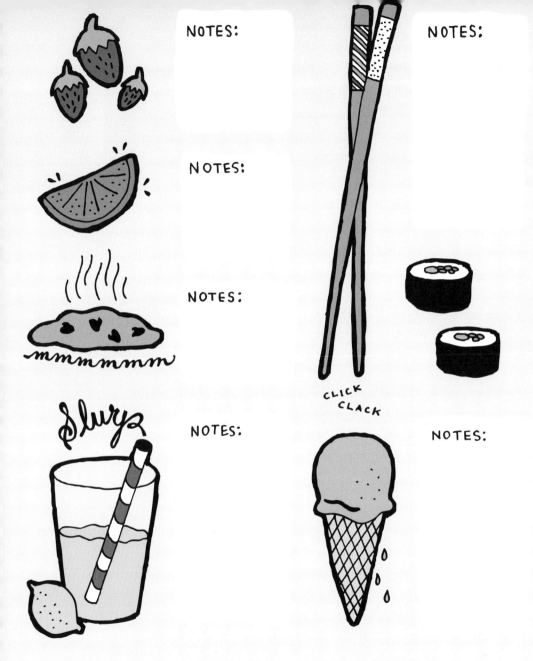

NOTES:

NOTES:

NOTES:

NOTES:

CLICK
CLACK

NOTES:

NOTES:

Jot down any memories you have associated with each of these foods.
Then rotate and compare notes.

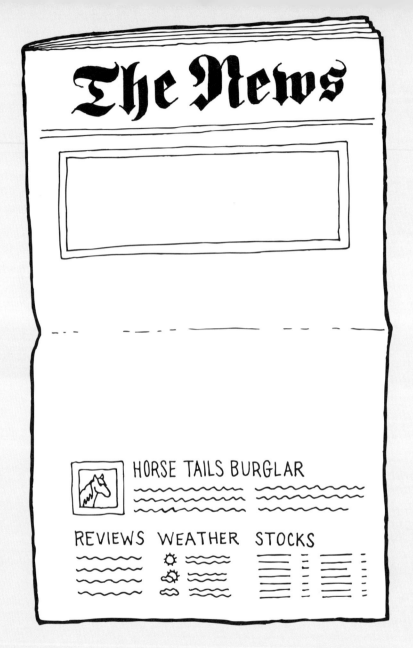

The morning paper just arrived. What do you wish was on the front page? Fill the newspaper with the best news you can imagine, then rotate the book and share.

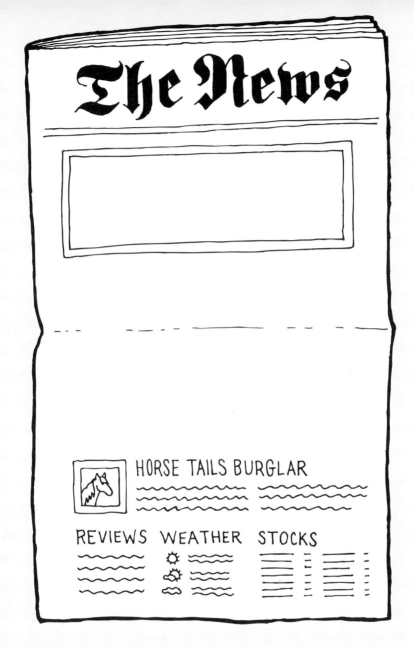

The morning paper just arrived. What do you wish was on the front page?
Fill the newspaper with the best news you can imagine, then rotate the
book and share.

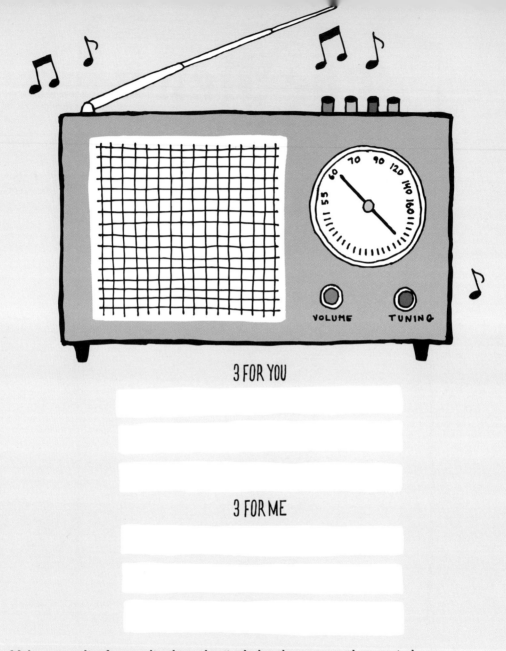

3 FOR YOU

3 FOR ME

Make a song list for a radio show that includes three songs that remind you of your friend and three songs that are about you. Rotate the book, try to hum your friend's songs, and explain your choices.

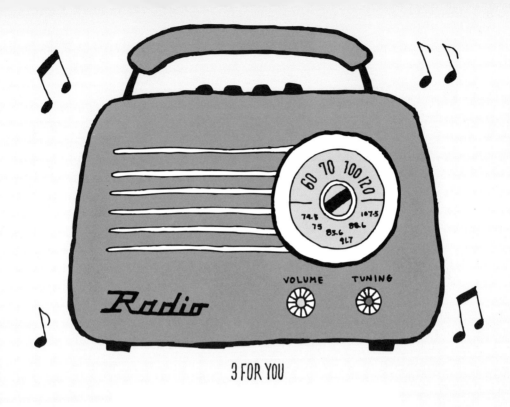

3 FOR YOU

3 FOR ME

Make a song list for a radio show that includes three songs that remind you of your friend and three songs that are about you. Rotate the book, try to hum your friend's songs, and explain your choices.

What would your friend pack on a dream trip? Where is he or she going?
Draw or write your best guess, then rotate and revise your own packing list.

TO RUMBLE ...

N THE RING ...

woohoo!

BOUT 1 BOUT 2 BOUT 3 BOUT 4 BOUT 5

WINS

Best of Five

Describe or draw your favorite part of your favorite holiday.

Here, dream up a holiday you wish existed. Describe or draw the festivities and decorations. Rotate and share, and determine whether you would want to observe your friend's holiday.

Describe or draw your favorite part of your favorite holiday.

Here, dream up a holiday you wish existed. Describe or draw the festivities and decorations. Rotate and share, and determine whether you would want to observe your friend's holiday.

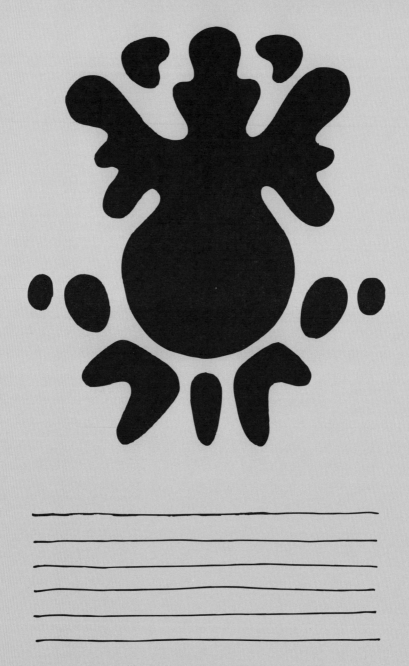

Rorschach test. What do you see? Try it from different angles. Compare notes.

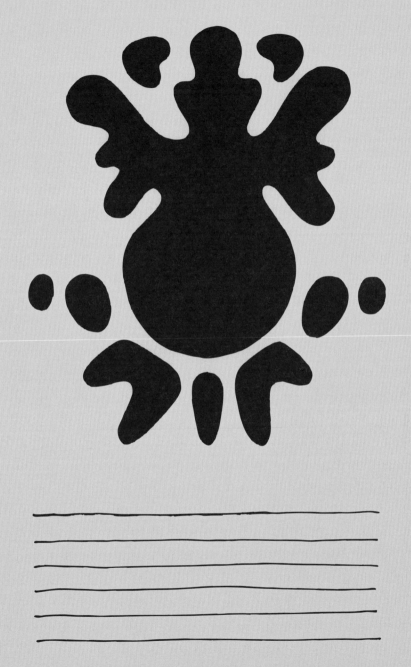

Rorschach test. What do you see? Try it from different angles. Compare notes.

If these were on sale, I'd buy heaps of them in a heartbeat!
Draw the items, then add a sale sign showing the discount
percentage of your dreams. Share.

If these were on sale, I'd buy heaps of them in a heartbeat!
Draw the items, then add a sale sign showing the discount
percentage of your dreams. Share.

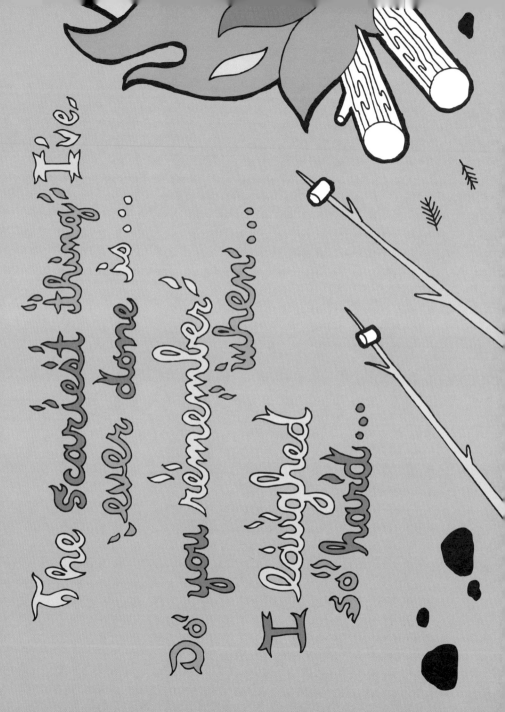

Trade stories, any stories. Optional: start with one of these sparks.

The scariest thing I've ever done is...

Do you remember when...

I laughed so hard...

It was such a wild coincidence when...

It was the dreamiest situation...

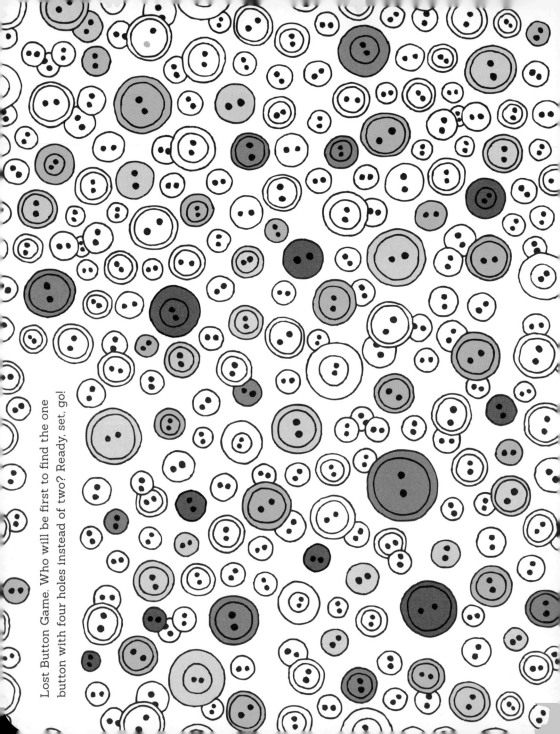

Lost Button Game. Who will be first to find the one button with four holes instead of two? Ready, set, go!

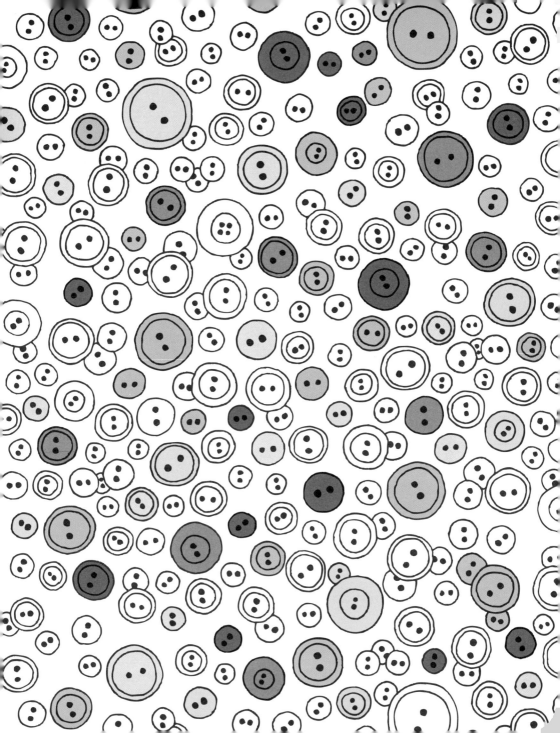

Draw the floor plan of your childhood home. Give your friend a tour. (Feel free to add furniture if you remember it!)

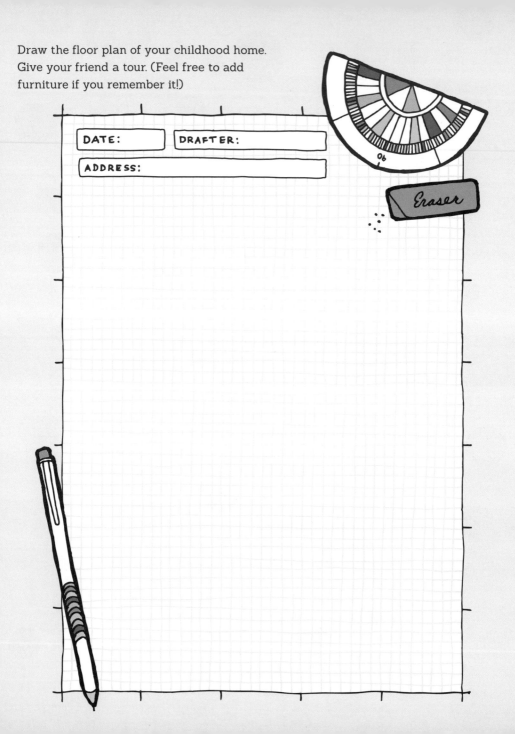

DATE:

DRAFTER:

ADDRESS:

Draw the floor plan of your childhood home.
Give your friend a tour. (Feel free to add
furniture if you remember it!)

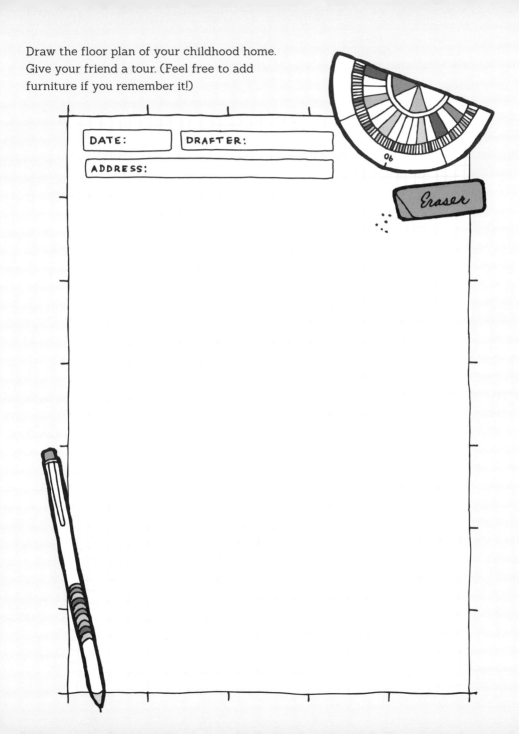

DATE:

DRAFTER:

ADDRESS:

Sometimes life is stressful. Sometimes we must do scary things that make us nervous. Draw a "friendly stress buddy" for your friend, something he or she can imagine when in need of some encouragement.

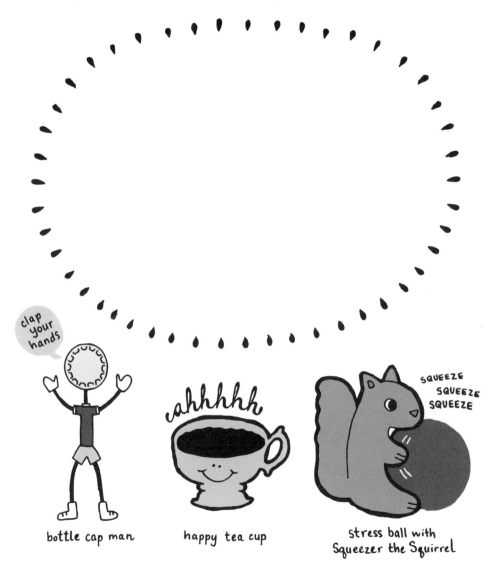

clap your hands

bottle cap man

ahhhhh

happy tea cup

SQUEEZE
SQUEEZE
SQUEEZE

stress ball with
Squeezer the Squirrel

Rotate and commit your new buddy to memory. (Or take a photo of it so you can find it again when you're most in need.)

Sometimes life is stressful. Sometimes we must do scary things that make us nervous. Draw a "friendly stress buddy" for your friend, something he or she can imagine when in need of some encouragement.

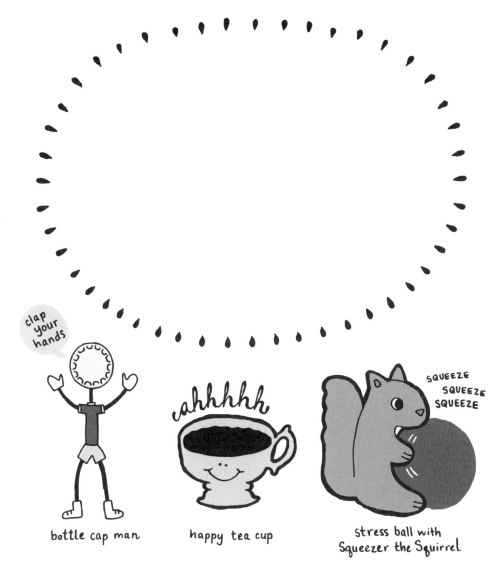

clap your hands

bottle cap man

ahhhhh

happy tea cup

SQUEEZE
SQUEEZE
SQUEEZE

stress ball with
Squeezer the Squirrel

Rotate and commit your new buddy to memory. (Or take a photo of it so you can find it again when you're most in need.)

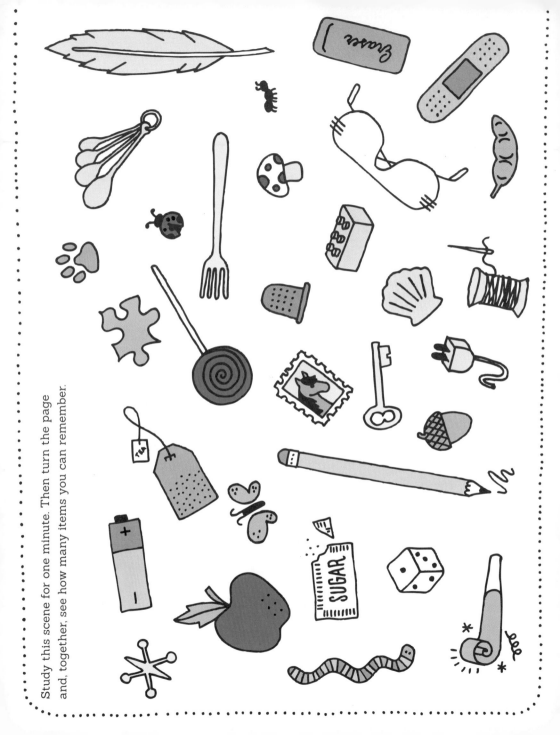

Study this scene for one minute. Then turn the page and, together, see how many items you can remember.

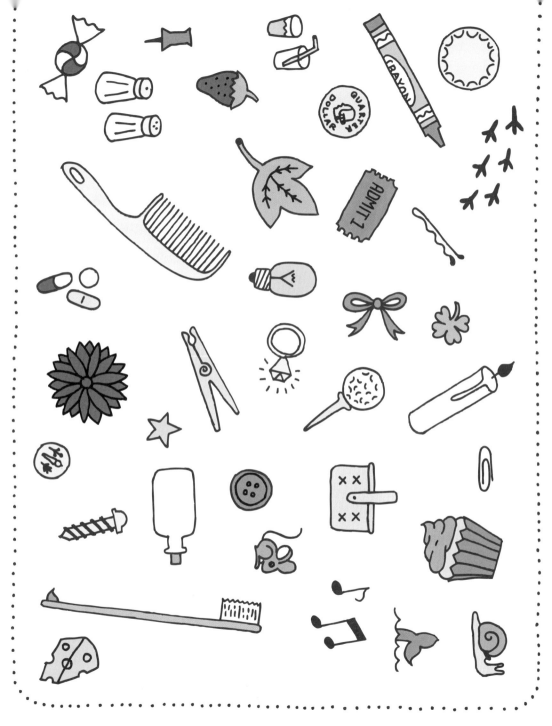

Here, draw or list the items you can remember from
the previous page.

At a restaurant, ask the server to surprise each of
you with an item. When they arrive, share them.
Draw what you got here. Did you like it?

At a restaurant, ask the server to surprise each of you with an item. When they arrive, share them. Draw what you got here. Did you like it?

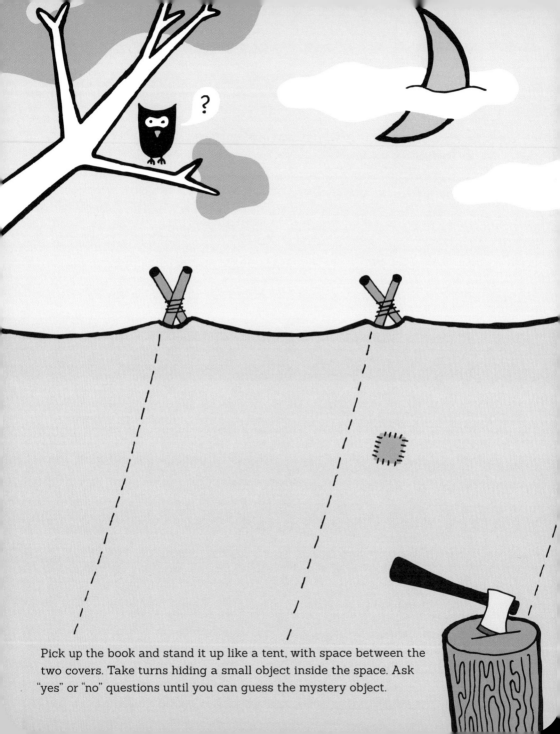

Pick up the book and stand it up like a tent, with space between the two covers. Take turns hiding a small object inside the space. Ask "yes" or "no" questions until you can guess the mystery object.

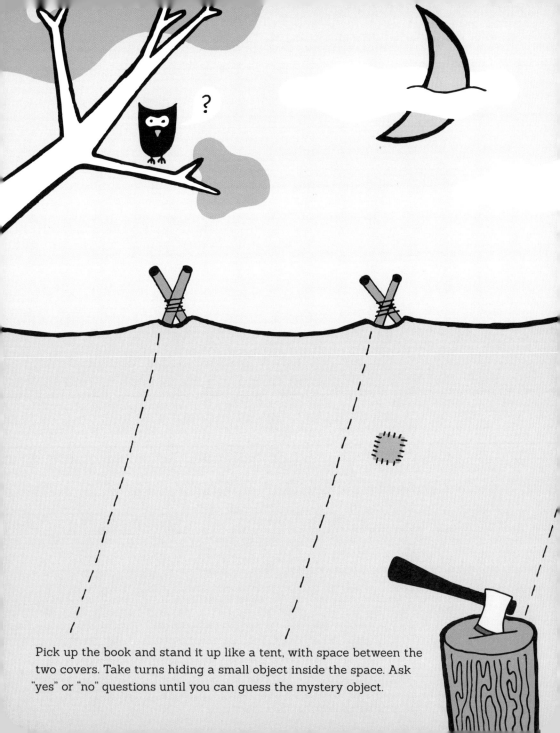

Pick up the book and stand it up like a tent, with space between the two covers. Take turns hiding a small object inside the space. Ask "yes" or "no" questions until you can guess the mystery object.

Design a menu for an imaginary restaurant. It can be as delicious or absurd as you like. Rotate the book and place a pretend order from your friend's menu.

Design a menu for an imaginary restaurant. It can be as delicious or absurd as you like. Rotate the book and place a pretend order from your friend's menu.

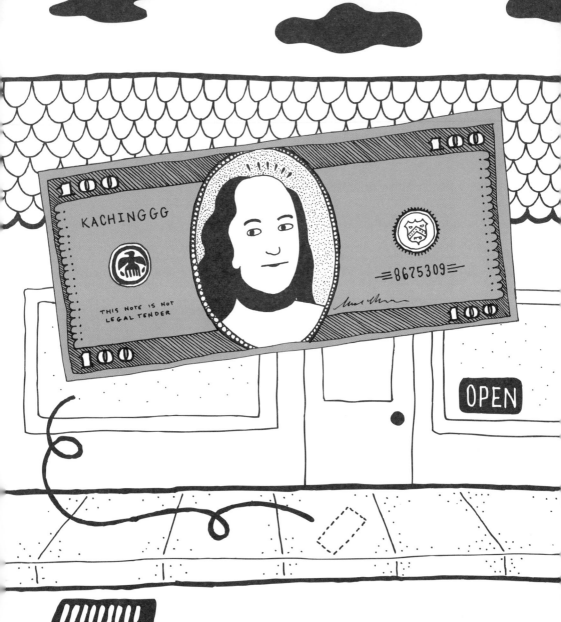

If I found this on the sidewalk . . .
Talk about it.

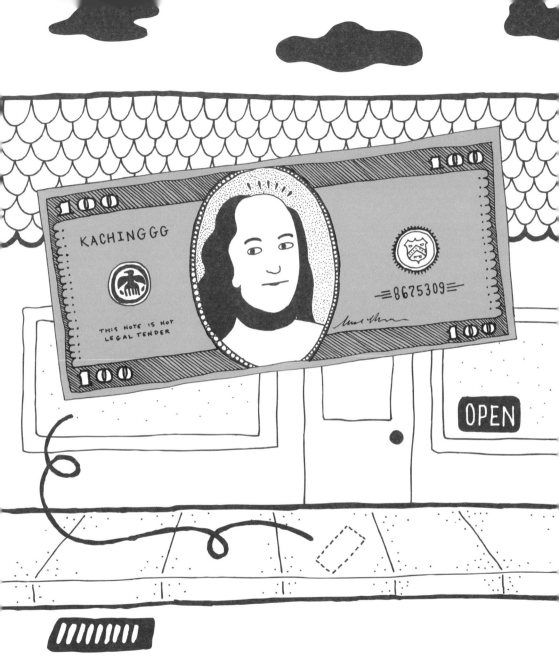

If I found this on the sidewalk . . .
Talk about it.

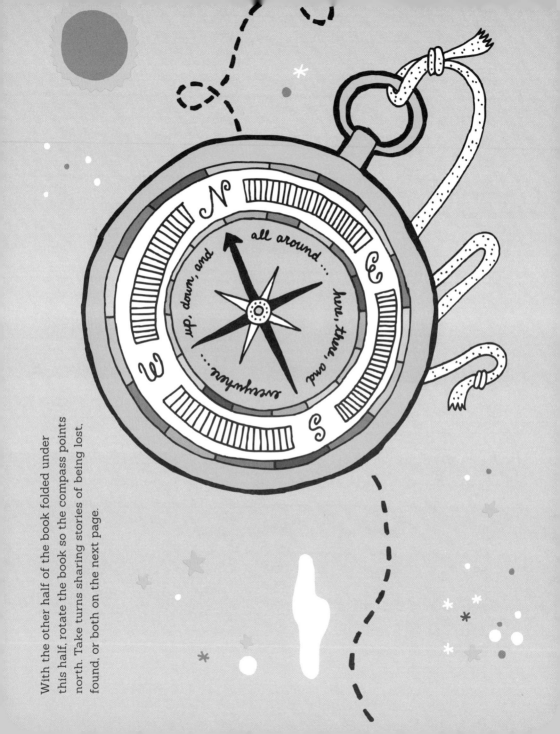

With the other half of the book folded under this half, rotate the book so the compass points north. Take turns sharing stories of being lost, found, or both on the next page.

NOTES

On the importance
of being lost...

~~~~~~~~~~~~~~~~

On the joys of
being found...

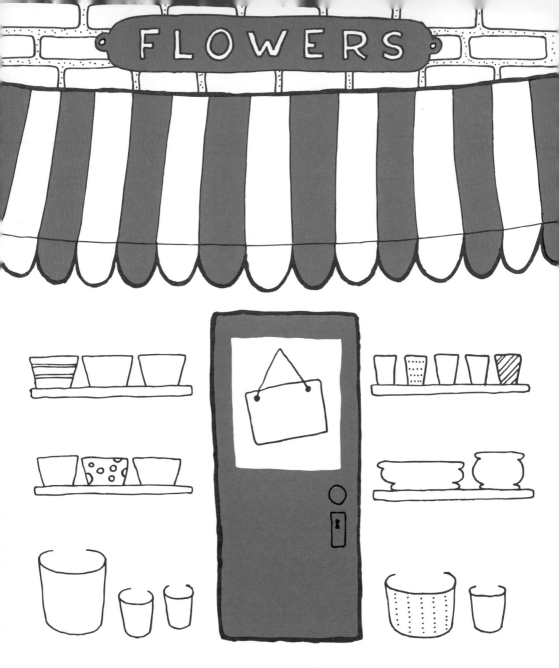

At your own personal flower shop, what flowers would you offer?
Draw, color, and compare.

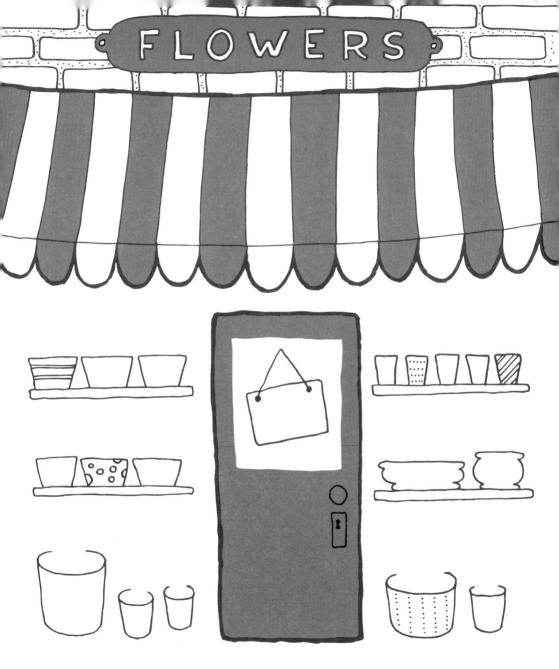

At your own personal flower shop, what flowers would you offer?
Draw, color, and compare.

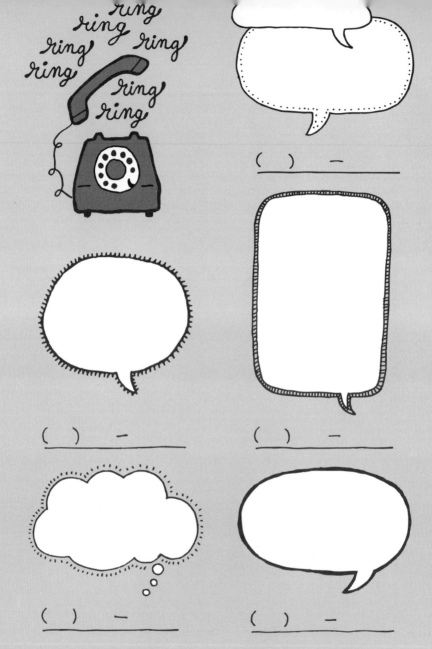

( ) _____ − _____

( ) _____ − _____

( ) _____ − _____

( ) _____ − _____

( ) _____ − _____

How many phone numbers do you know by heart? Can you remember your childhood phone number? Take turns dialing these numbers and sharing about the places and people they connect to. Record your findings.

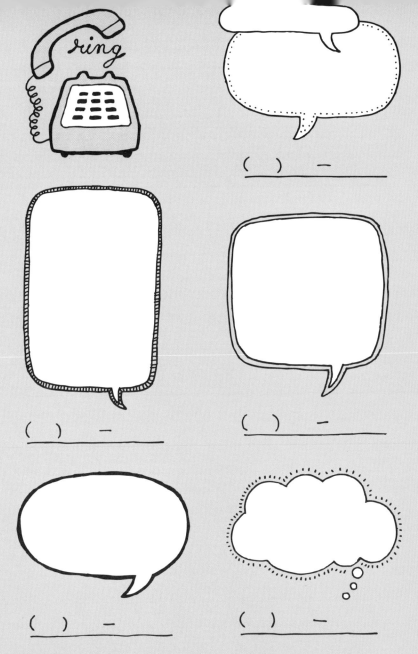

( )    – _____

( )    – _____

( )    – _____

( )    – _____

( )    – _____

How many phone numbers do you know by heart? Can you remember your childhood phone number? Take turns recording these numbers and sharing about the places and people they connect to.

Draw the floor plan of your dream home, complete with a yard. Give your friend a tour.

DATE:

DRAFTER:

ADDRESS:

Eraser

Draw the floor plan of your dream home, complete with a yard. Give your friend a tour.

DATE:

DRAFTER:

ADDRESS:

06

Eraser

Award your friend a trophy. What is he or she awesome at?
Draw a custom trophy top!

Award your friend a trophy. What is he or she awesome at?
Draw a custom trophy top!

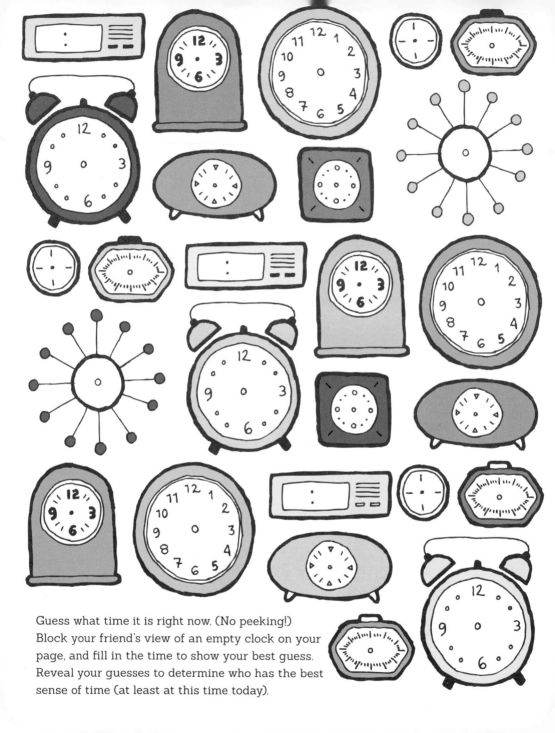

Guess what time it is right now. (No peeking!)
Block your friend's view of an empty clock on your
page, and fill in the time to show your best guess.
Reveal your guesses to determine who has the best
sense of time (at least at this time today).

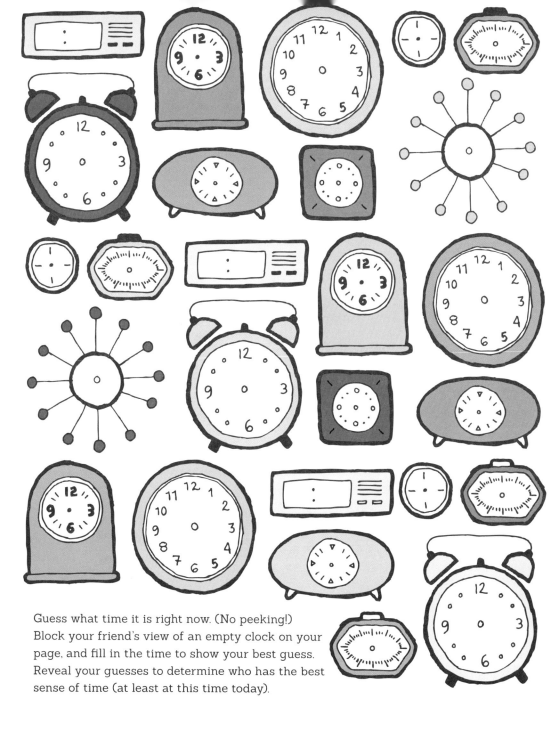

Guess what time it is right now. (No peeking!)
Block your friend's view of an empty clock on your
page, and fill in the time to show your best guess.
Reveal your guesses to determine who has the best
sense of time (at least at this time today).

Trace each other's hands and give imaginary palm readings.
Record your findings here.

Trace each other's hands and give imaginary palm readings.
Record your findings here.

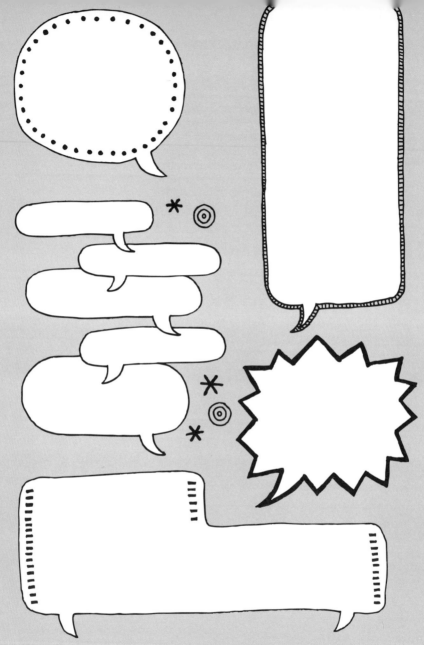

Sit in a café and listen to other people's conversations instead of your own. Jot down anything you find interesting. Respond only with facial expressions to your friend.

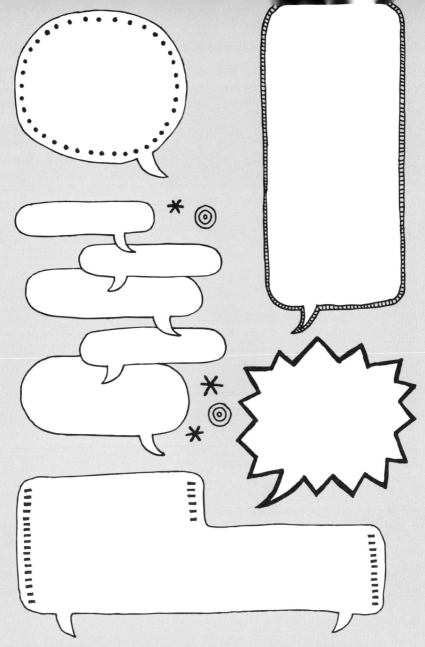

Sit in a café and listen to other people's conversations instead of your own. Jot down anything you find interesting. Respond only with facial expressions to your friend.

Invent your own constellations. Make as many as you like, working simultaneously across both pages. Connect the dots, name them, and share. (Optional: Invent myths to go with them.)

Cassiopeia

the BIG DIPPER

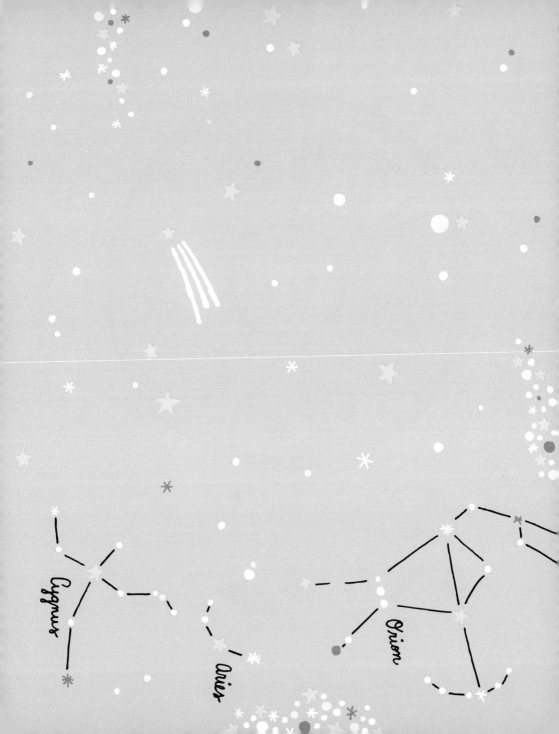

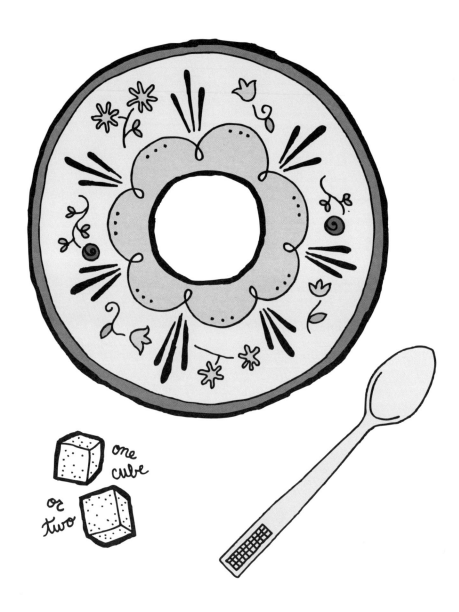

one cube

or two

At a café, order your favorite beverage and place it here on this saucer.
Rotate. Careful not to spill! Experience your friend's drink.

At a café, order your favorite beverage and place it here on this saucer. Rotate. Careful not to spill! Experience your friend's drink.

What is the best gift you have ever received?
Draw, rotate, and share.

What is the best gift you have ever received?
Draw, rotate, and share.

In a café, play tic-tac-toe with sugar packets.

Make a story s'more together. Alternating turns, add a phrase next to each ingredient until you've coauthored a delicious short story.

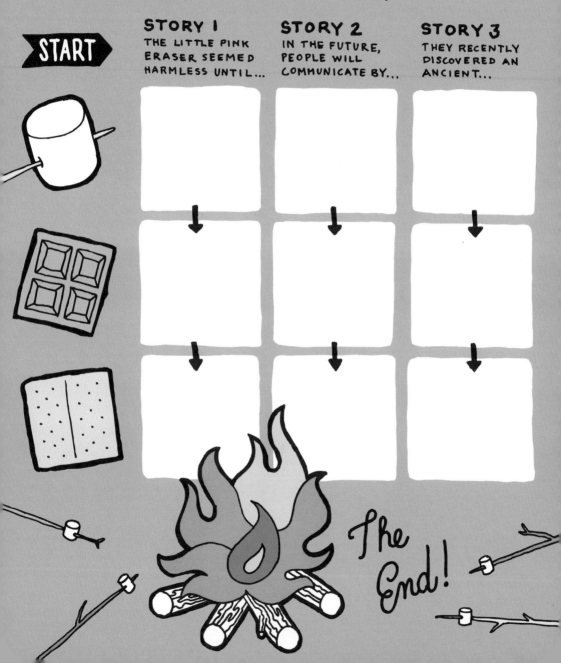

**START**

**STORY 1**
THE LITTLE PINK ERASER SEEMED HARMLESS UNTIL...

**STORY 2**
IN THE FUTURE, PEOPLE WILL COMMUNICATE BY...

**STORY 3**
THEY RECENTLY DISCOVERED AN ANCIENT...

The End!

Make a story s'more together. Alternating turns, add a phrase next to each ingredient until you've coauthored a delicious short story.

**START**

**STORY 4**
HE WAS ALWAYS WEARING A BOWTIE BECAUSE...

**STORY 5**
ON THE FAR SIDE OF THE MOON...

**STORY 6**
UP IN THE ATTIC, I FOUND A VERY OLD...

The End!

If you co-owned a factory, what would it produce?

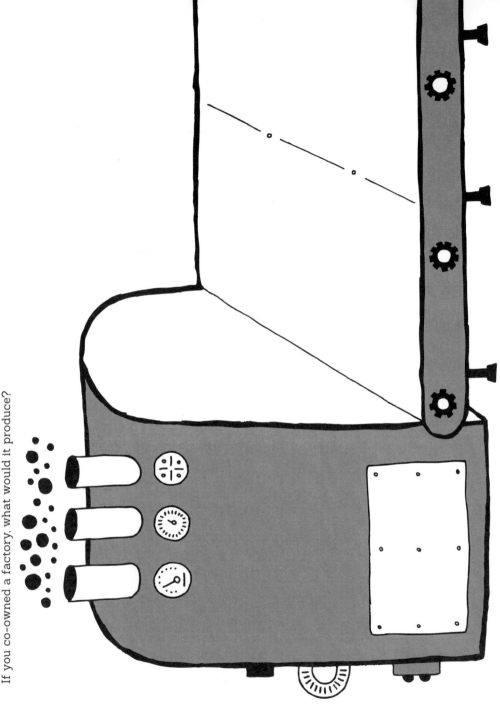

Do you have an awkward or hilarious story from your past? You're not alone. Draw or write your tale here. Then rotate and share. Can you laugh about it in the present?

Do you have an awkward or hilarious story from your past? You're not alone. Draw or write your tale here. Then rotate and share. Can you laugh about it in the present?

Draw 15 to 20 of your personal possessions. Study the objects on both pages for one minute. Then turn the page and, working together, try to list all of the objects from memory.

Draw 15 to 20 of your personal possessions. Study the objects on both pages for one minute. Then turn the page and, working together, try to list all of the objects from memory.

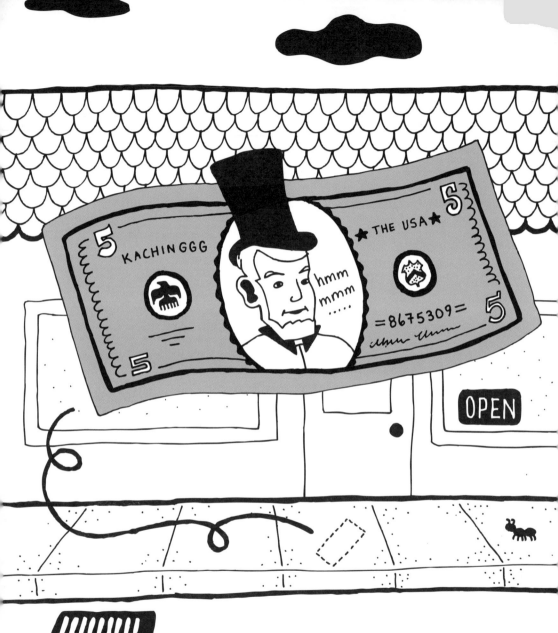

If I found this on the sidewalk . . .
Talk about it.

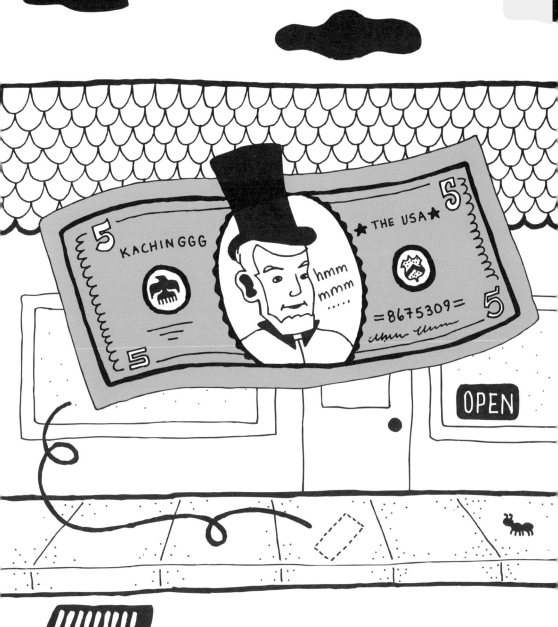

If I found this on the sidewalk . . .
Talk about it.

Without looking at them first, try to draw your keys with as much accuracy and detail as possible. Then pull out your keys and see how you did!

Rotate and add a silly key chain to your friend's keys.

Without looking at them first, try to draw your keys with as much accuracy and detail as possible. Then pull out your keys and see how you did!

Rotate and add a silly key chain to your friend's keys.

Get on your soapbox! Pretend you're about to give an impromptu public speech. What are a few things that you'd like to tell the world?

Rotate and add comments from the peanut gallery.

OFFENSE

GOALS

DEFENSE

FOLD HERE

GOAL!

If you were in this balloon together, where would you like to be floating? Draw yourselves in the balloon and the landscape below.

I, _____ (insert name), do hereby promise to take important risks in life, such as the following:

1)

2)

3)

Signature _____

Witness signature _____

Date _____

I, _____ (insert name), do hereby promise to take important risks in life, such as the following:

1)

2)

3)

Signature _____

Witness signature _____

Date _____

Find someone to make a quick sketch of the two of you together.

BY:

Draw a comic that you think your friend might enjoy. It can be a true story (perhaps a shared memory) or something from your imagination.

BY:

Draw a comic that you think your friend might enjoy. It can be a true story
(perhaps a shared memory) or something from your imagination.

What's inside your heart of hearts? What matters to you the most? (Draw or write.) Rotate and share.

What's inside your heart of hearts? What matters to you the most?
(Draw or write.) Rotate and share.

Take turns spinning your pen on the dials and answering the questions it points to. Add your own questions, too. Tell each other your stories.

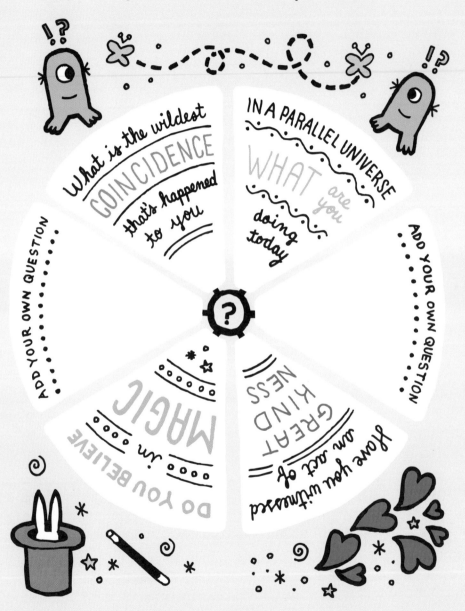

Take turns spinning your pen on the dials and answering the questions it points to. Add your own questions, too. Tell each other your stories.

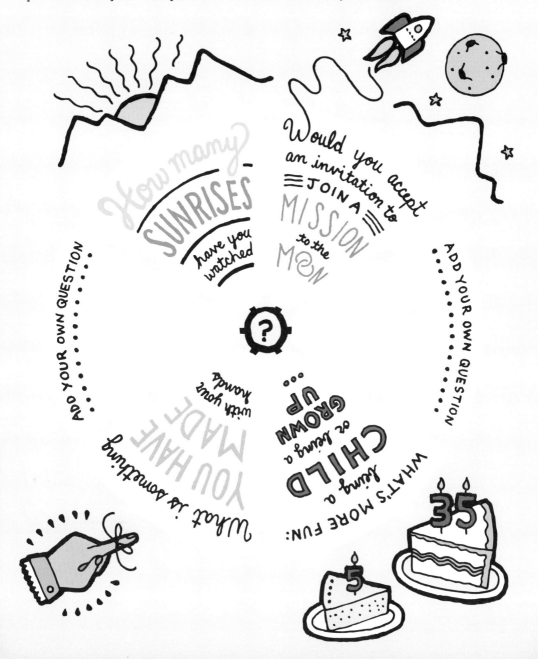

How many SUNRISES have you watched

Would you accept an invitation to JOIN A MISSION to the MOON

ADD YOUR OWN QUESTION

ADD YOUR OWN QUESTION

What is something YOU HAVE MADE with your hands

WHAT'S MORE FUN: being a CHILD or being a GROWN UP

35

5

Toss a penny into this wishing well and silently make a wish.
Write your wish at the bottom of this page, tear it off, and tuck
it in your pocket. Keep it secret.

WISH #1 | WISH #2 | WISH #3

Toss a penny into this wishing well and silently make a wish.
Write your wish at the bottom of this page, tear it off, and tuck
it in your pocket. Keep it secret.

WISH #1

WISH #2

WISH #3

Hiding in this book somewhere (not on this page) are
five ants - tiny life-sized ants, just like these.
Who can find them first?

*Tandem Activity Book* was created by artist Lea Redmond.
Her creative workshop, Leafcutter Designs, offers curious
goods, surprising services, and projects for participation:
www.leafcutterdesigns.com.

Text copyright © 2015 by Lea Redmond.

Illustrations copyright © 2015 by Mette Hornung Rankin.

ISBN 978-1-4521-4017-9

Manufactured in China.

10 9 8 7 6 5 4 3 2 1

Chronicle Books LLC
680 Second Street
San Francisco, CA 94107
www.chroniclebooks.com